A Mark Dahle Portfolio

Any Pet I Wanted

Mark Dahle Portfolios can be read in a few minutes and enjoyed for a lifetime.

Mark Dahle Portfolios combine text with beautiful photographs and paintings. Unlike many picture books, the text in this book is unrelated to the art. This might seem really weird at first. One thing that helps is to order more portfolios so you get used to it. Until then, you may draw your own pictures of dragons on the pages if you like.

*This portfolio includes a children's story (*Any Pet I Wanted*), a photo of a brilliant 36 x 24 inch painting (at the right) and twenty-four beautiful industrial photographs taken near rail tracks in Grand Rapids, MI, Palm Springs, CA and San Ysidro, CA.*

Photographs in this book are available limited editions. See http://www.MarkDahle.com for more information and for previews of upcoming portfolios.

© Mark Dahle 2012. All rights reserved.

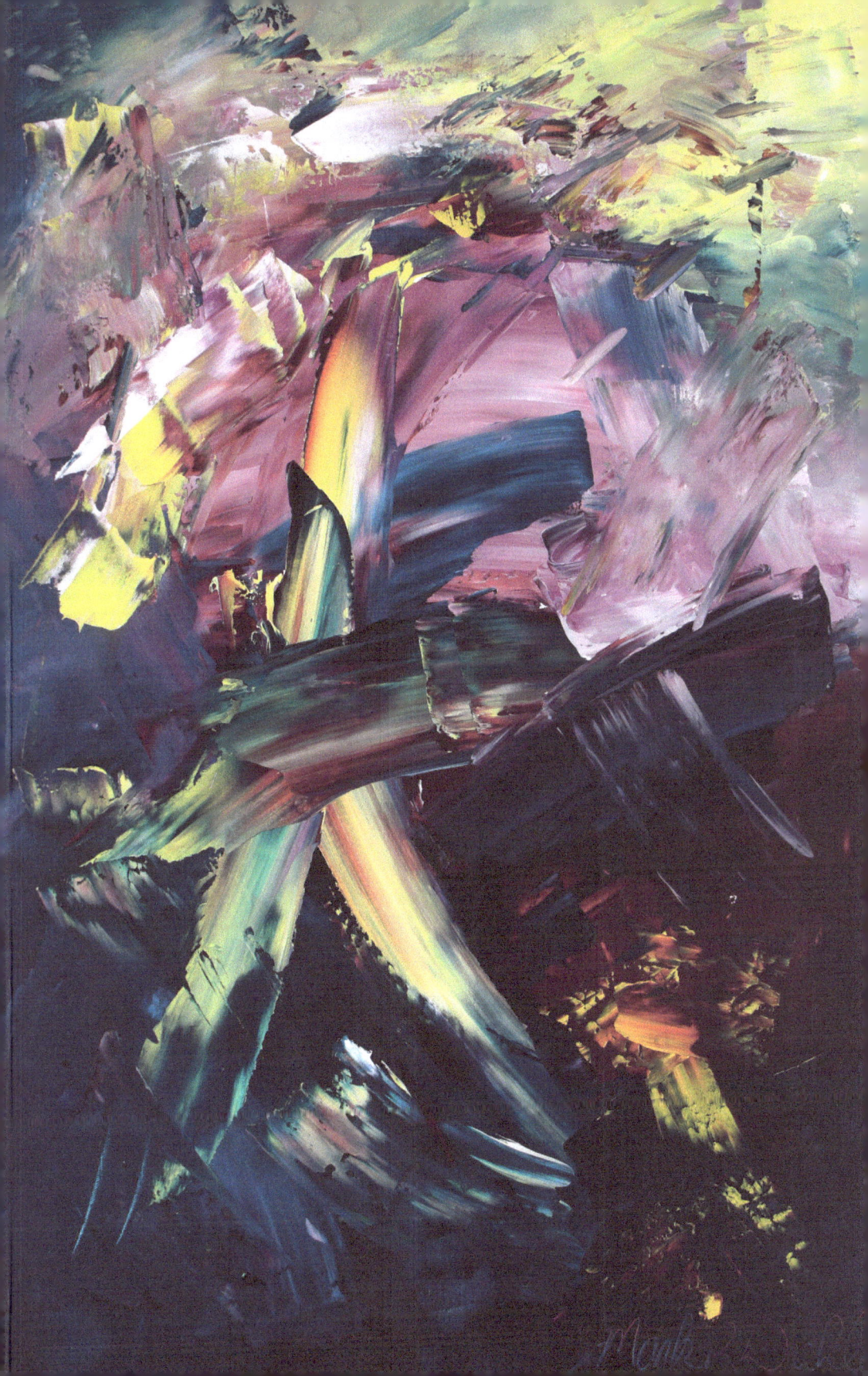

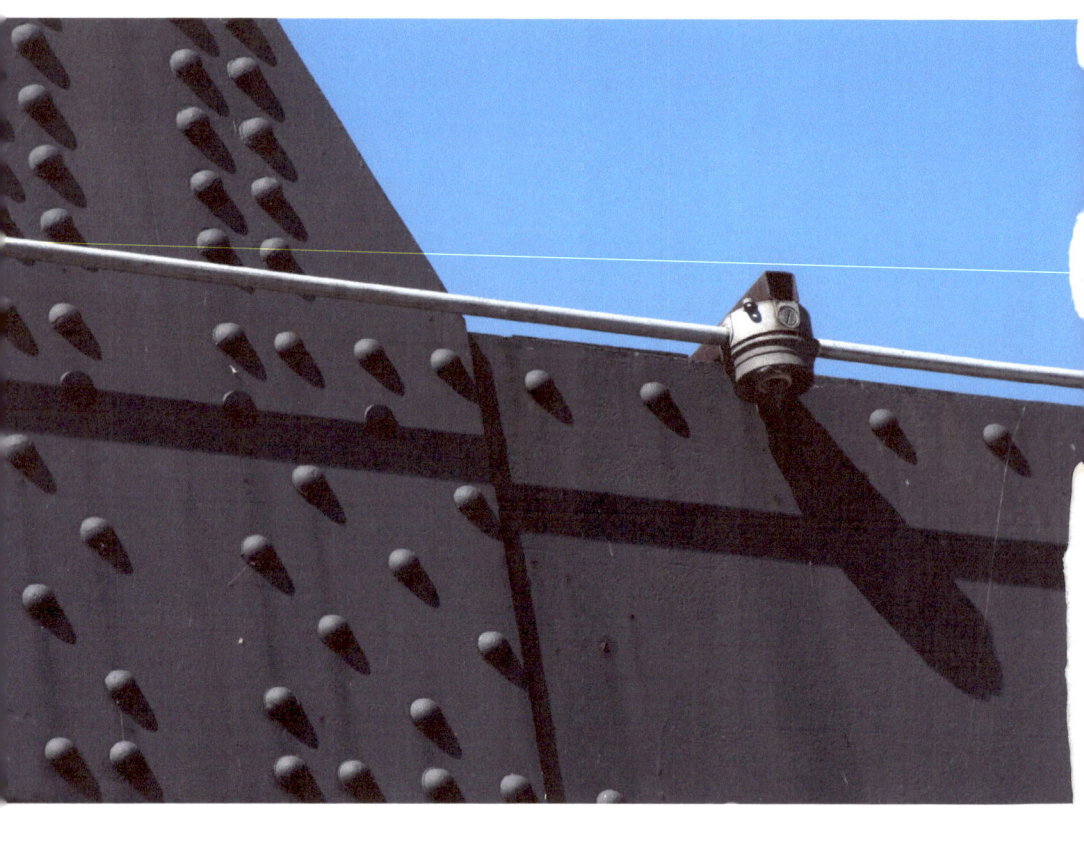

~ ~ ~

Mom and Dad said I could have a pet.
Any pet I wanted.

My Mom was hoping for a lop-eared bunny.

My Dad was thinking of an English sheep dog.

I wanted a dragon.

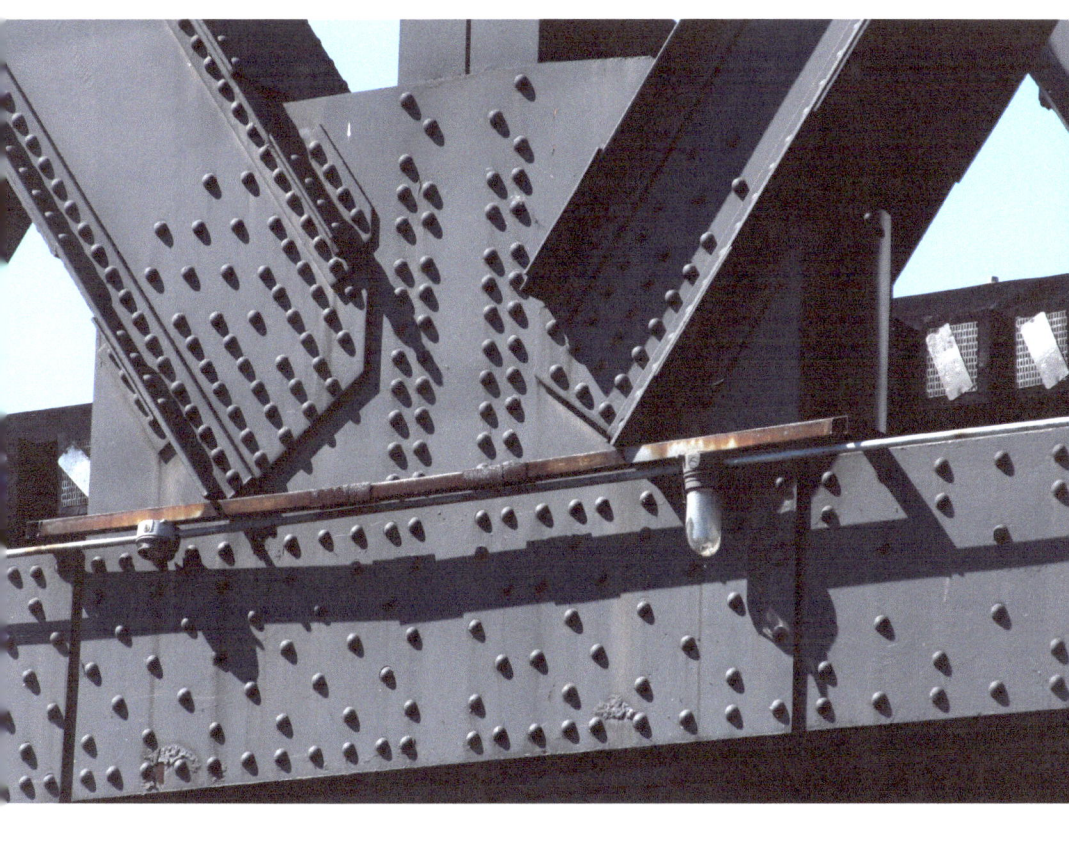

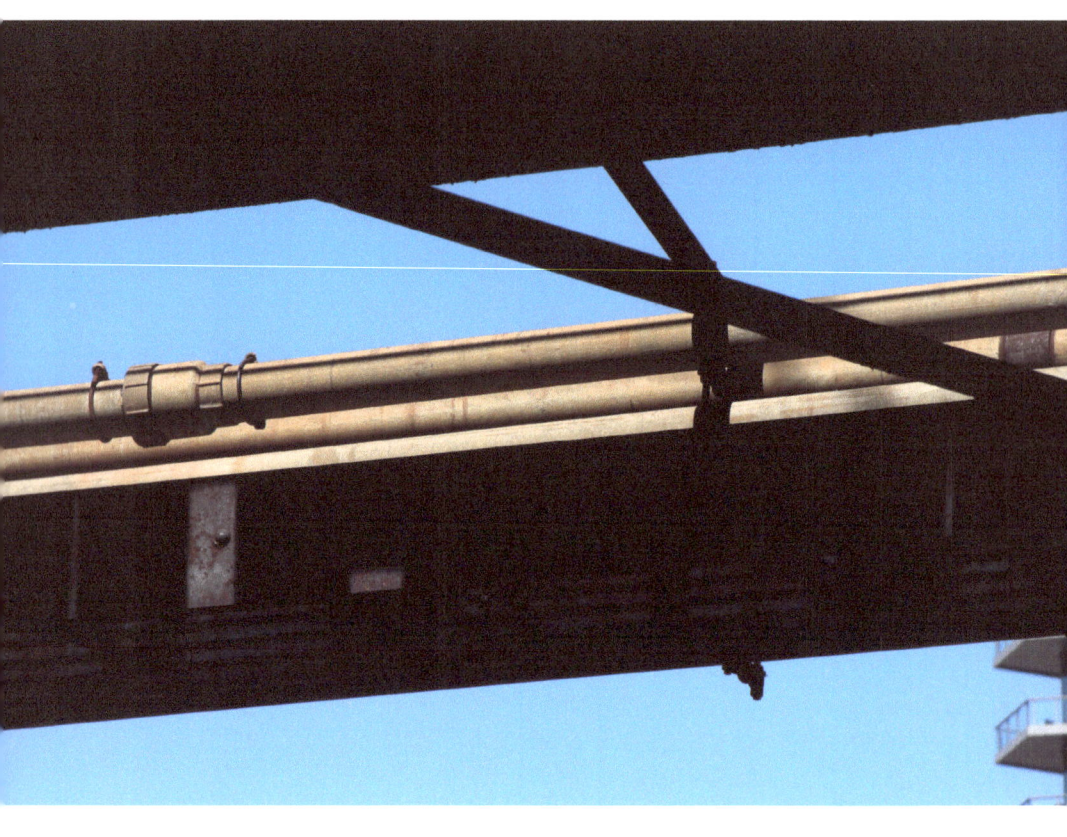

I looked at all the pets
at Miss Apataska's Amazing Pet Store:
snails, hamsters, goldfish. . .
even the lop-eared bunnies
and English sheep dogs.

But none looked as good as a dragon.

At the back of the shop I found a door with a sign: "Caution: Exotic Animals."

I pushed the door open slowly.

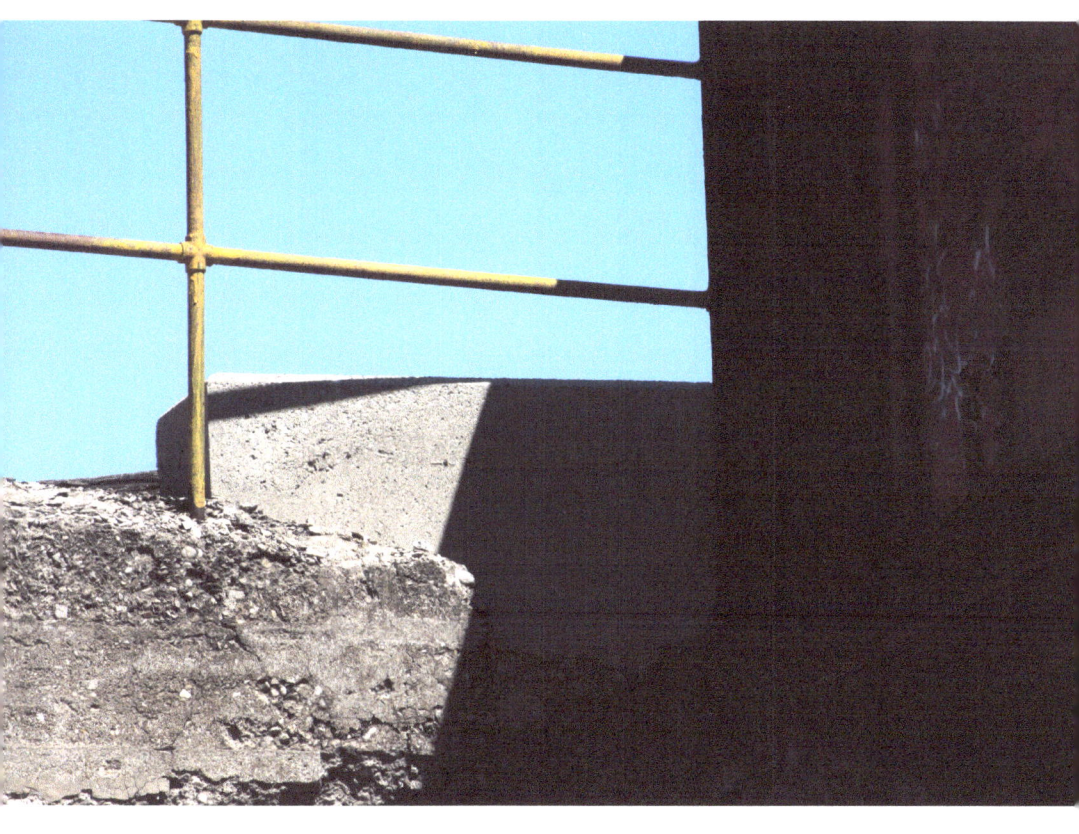

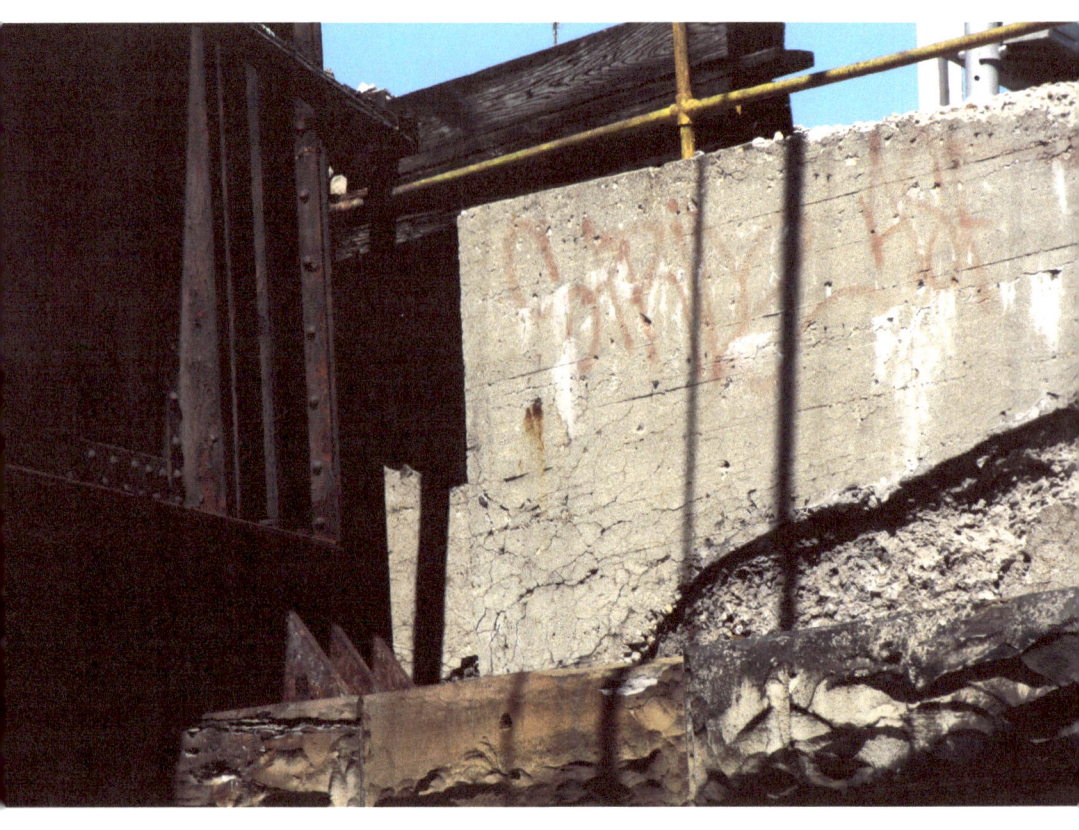

This was the right place to find a dragon!

I searched everywhere
and found eight dragons
in the Exotic Animal room.

I picked out the smallest one.

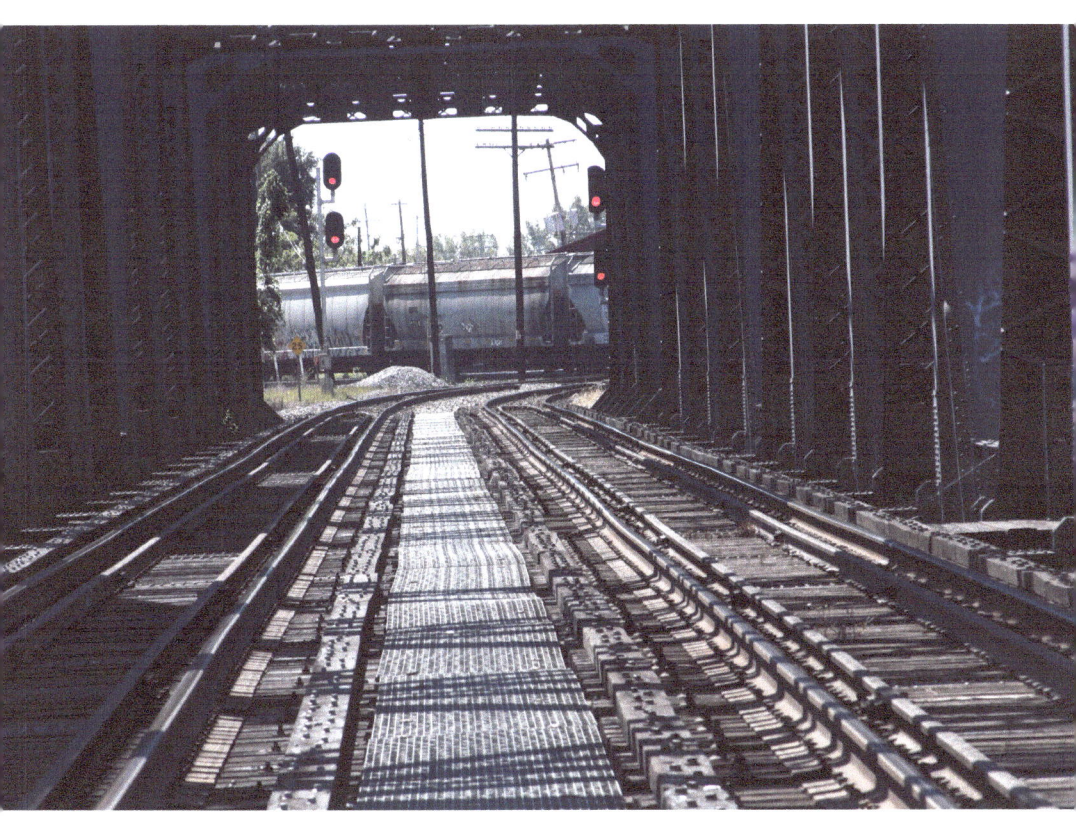

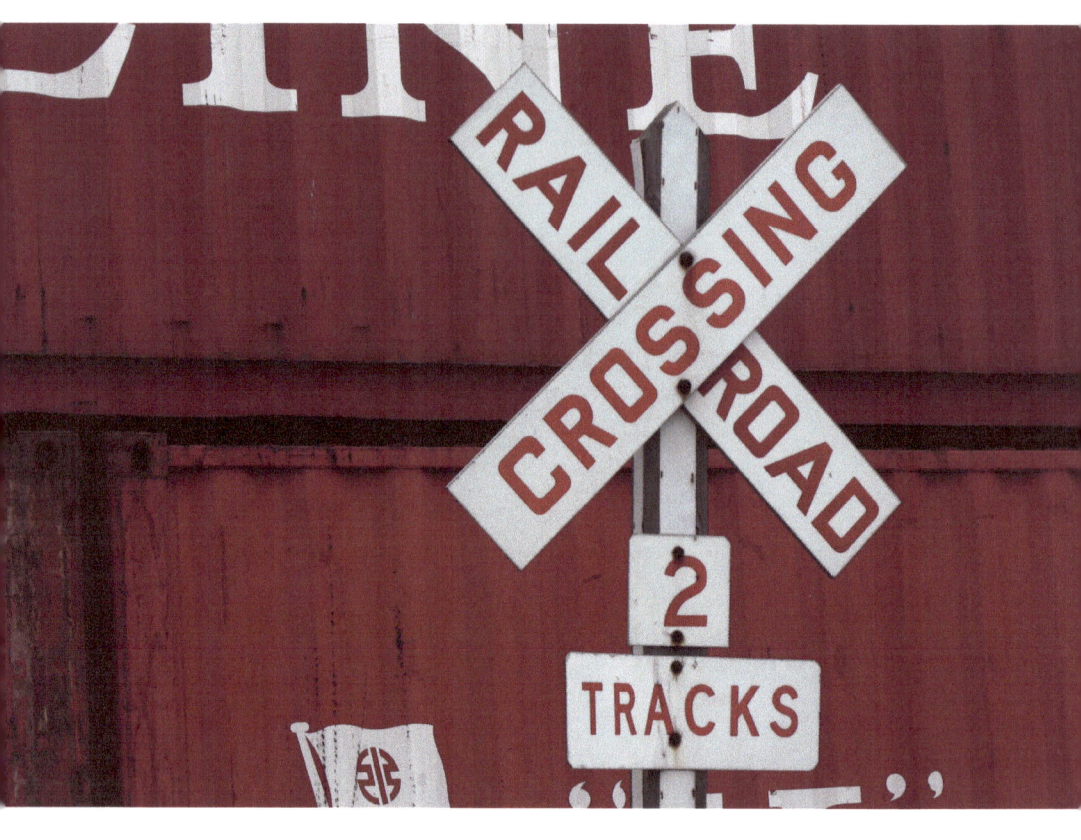

Mom and Dad bought a book called
Training Animals
That Will Grow Big Enough
To Eat You.

Luckily there was a sale on dragon food that day!

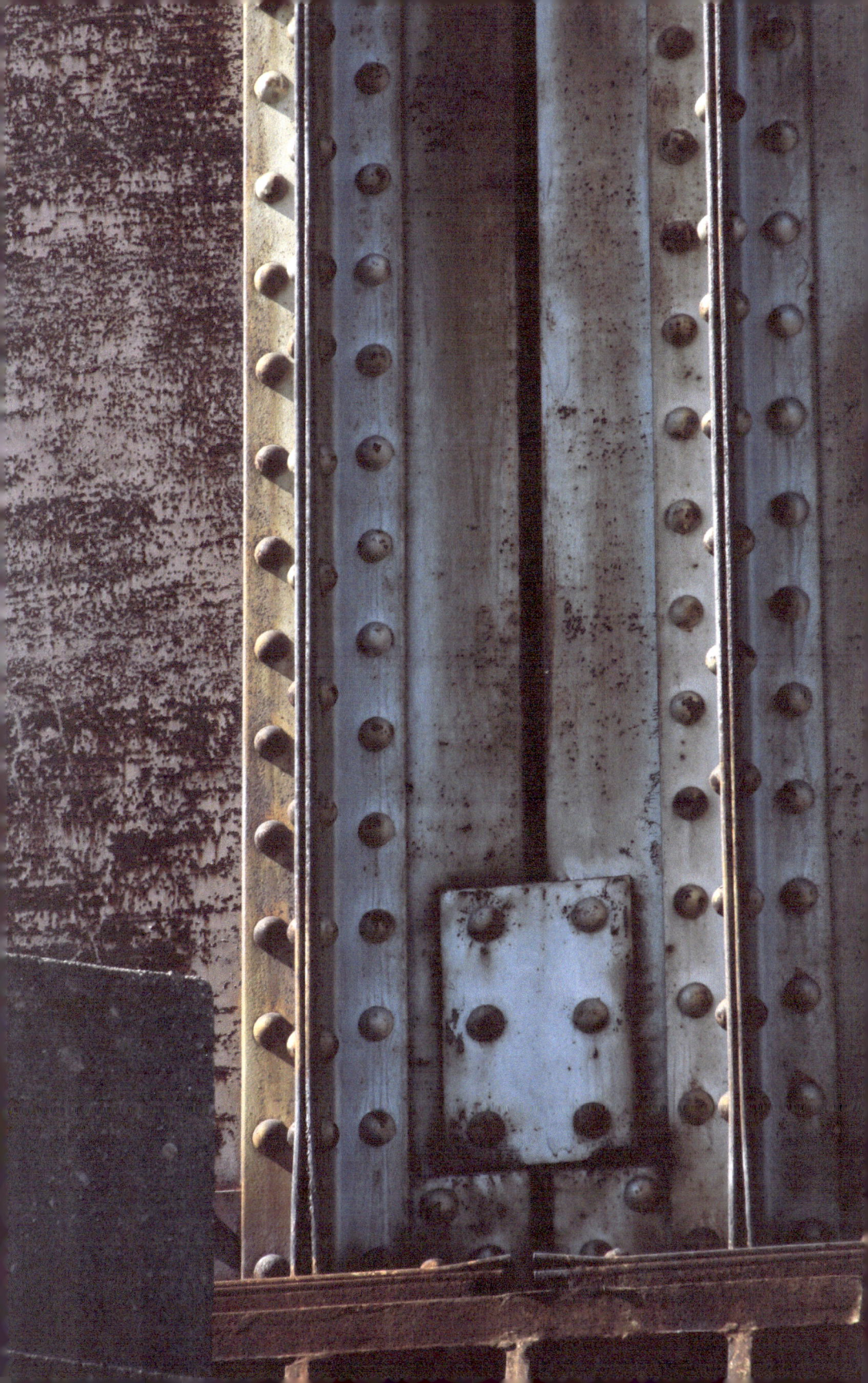

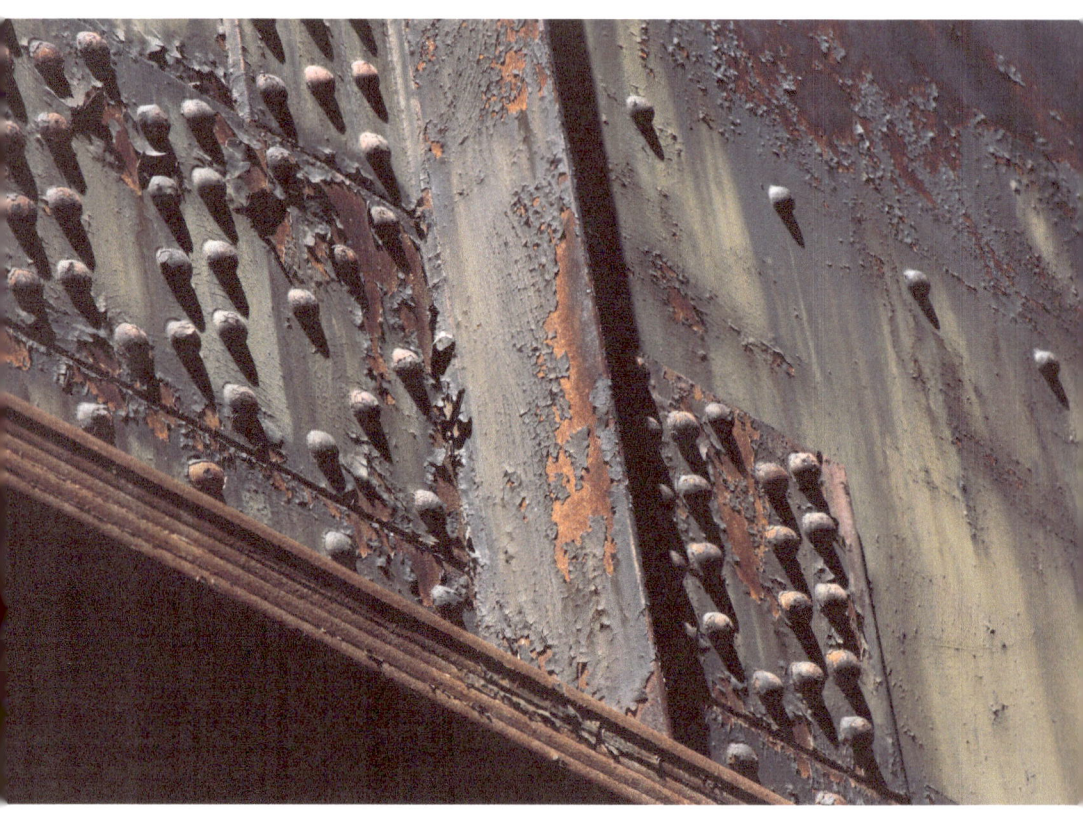

When we got home,
I started training my dragon right away.

But when my dragon
tried to light a fire in the fireplace,
he missed, and the curtains went up in flames.

Mom and Dad were mad
when the curtains caught fire.

That made my dragon so nervous
that he ate two weeks' worth
of dragon food for lunch.

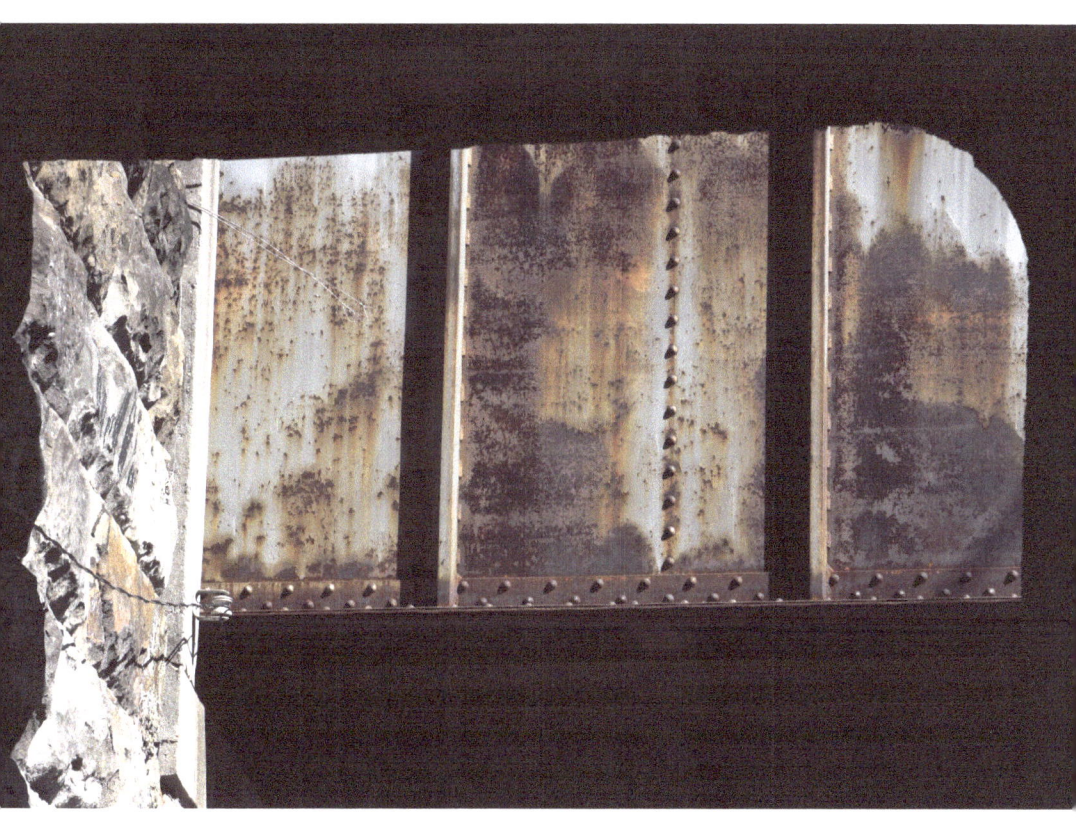

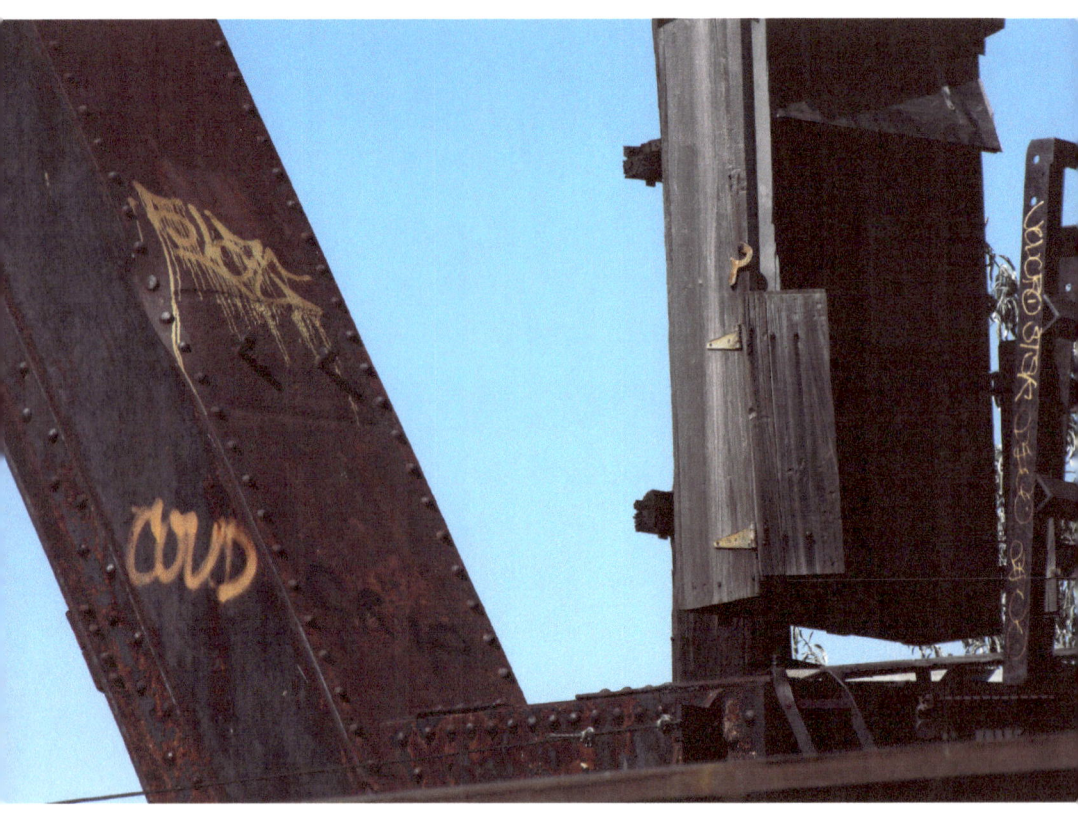

When he was done eating,
he burped so loud
he broke three glass windows.

After that he tried to be good.

But our house wasn't big enough for a dragon.

When he was being good
he accidentally knocked over
two lamps, four plants, and the sofa.

Mom and Dad were sitting in the sofa
when it happened.

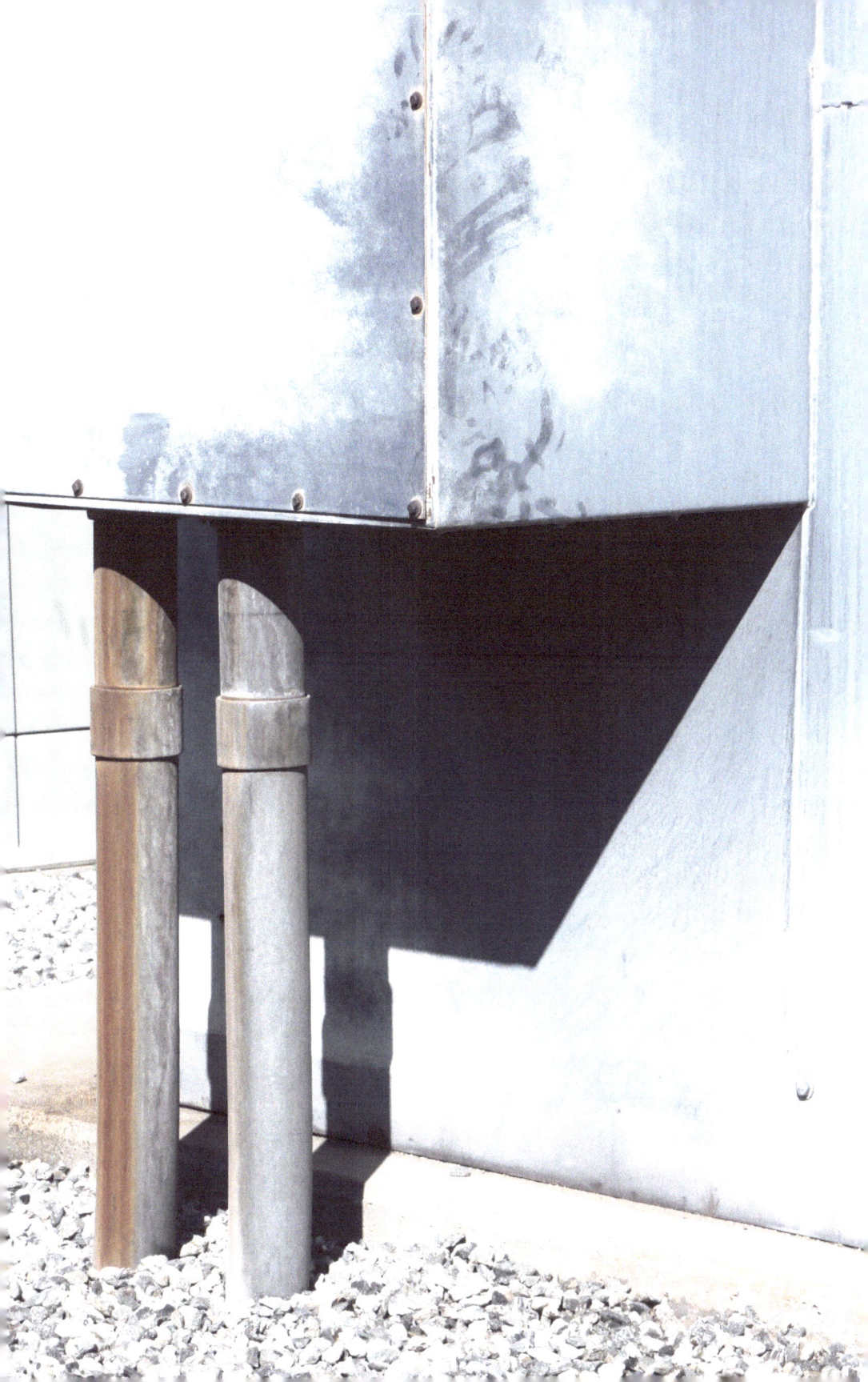

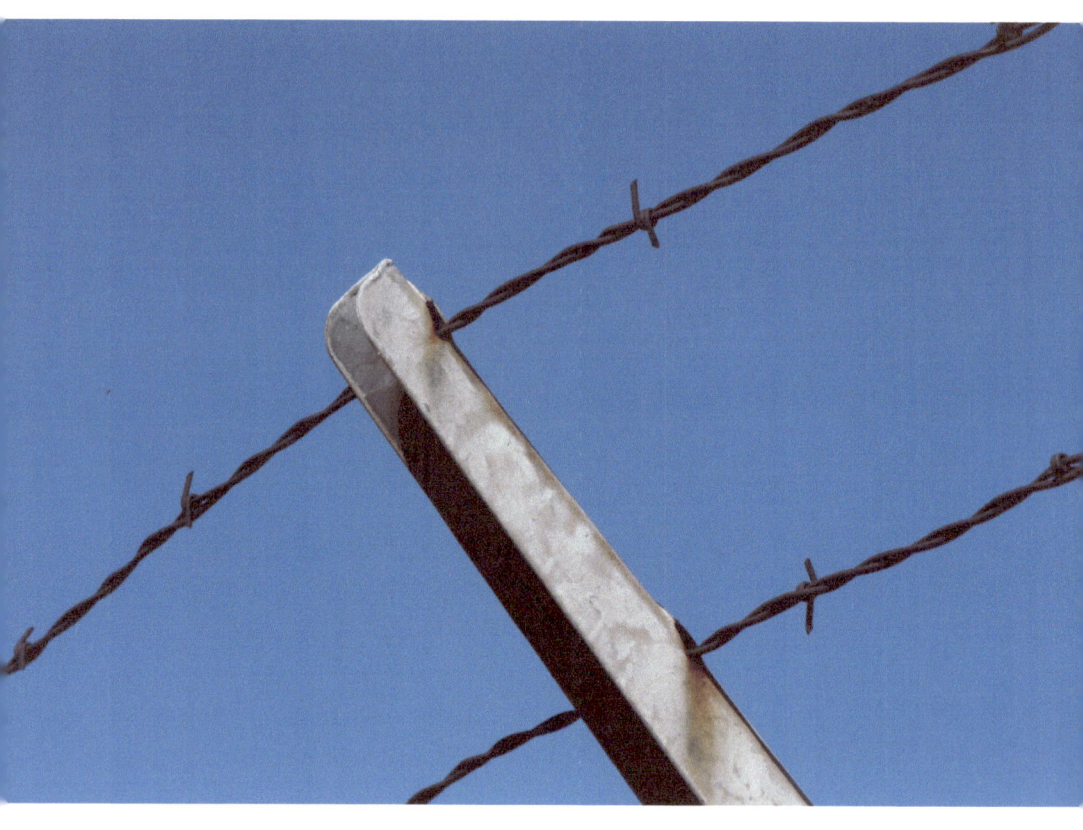

At dinner, my dragon
ate all his food in one gulp
and looked up for more.

While he was waiting for his second helping,
he ate the book about training big animals.

Now *I* was getting nervous!

At night, I put my dragon outside.

When he fell asleep,
he snored like a helicopter.

Nobody in the neighborhood could sleep.

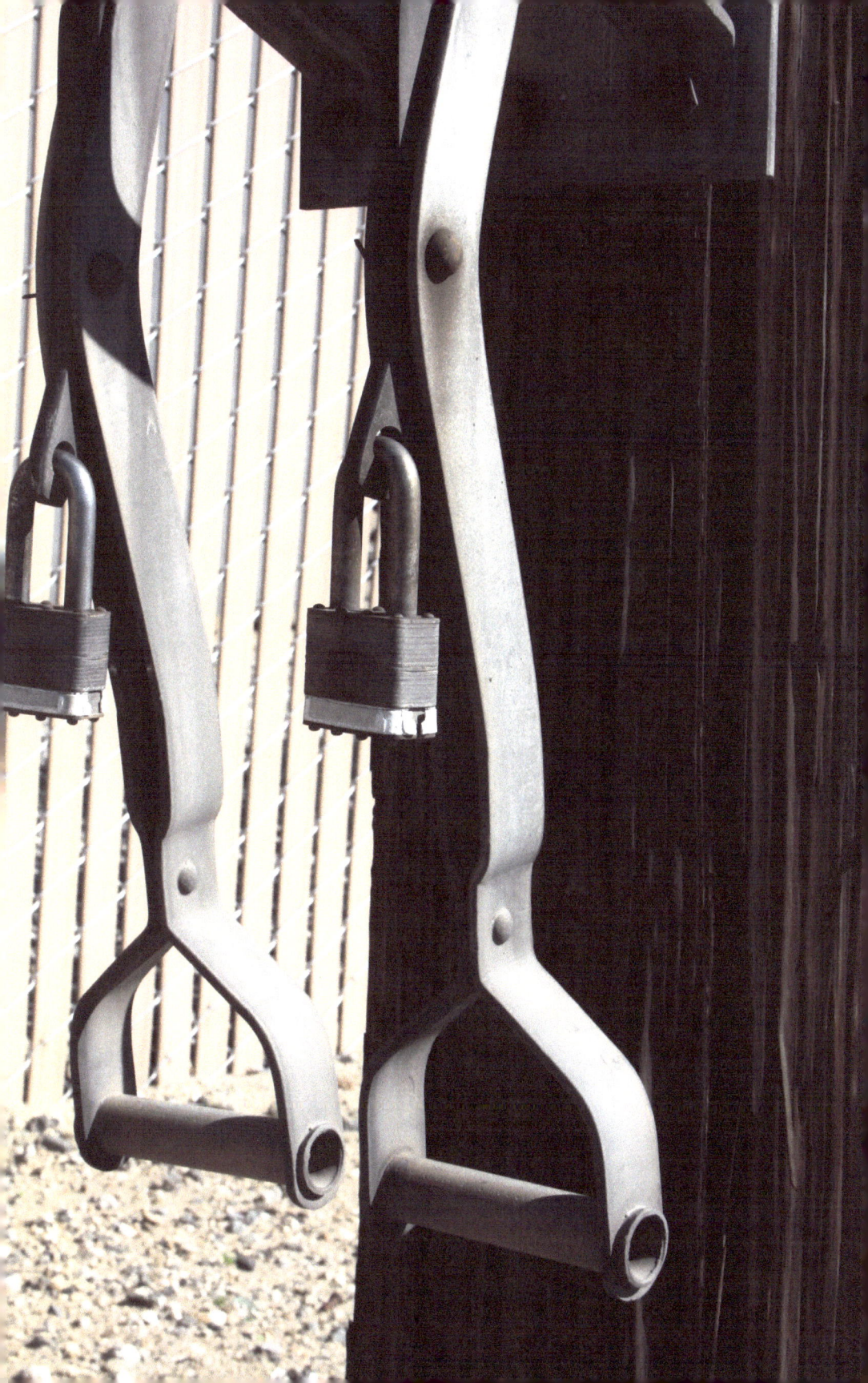

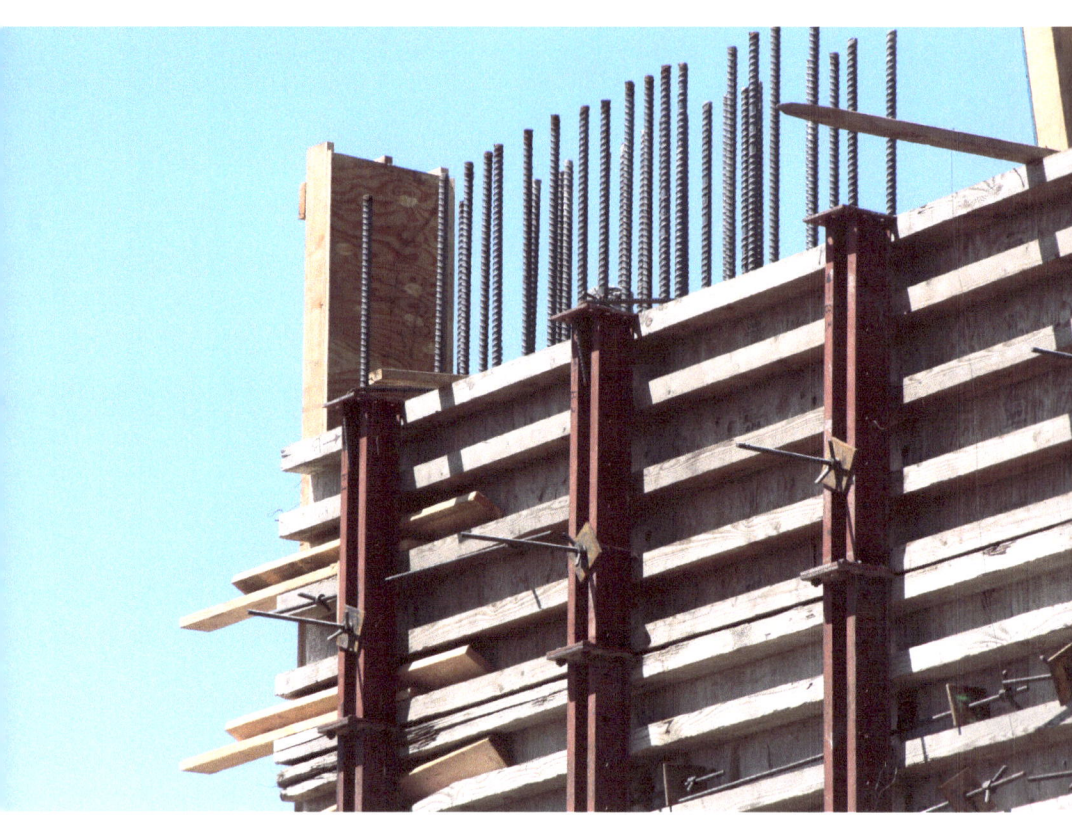

At breakfast, he ate *four* weeks' worth of dragon food
and he was looking at *me* hungrily
when all the food was gone.

Plus, he was growing fast.

At lunchtime he started crying.

He missed Miss Apataska.
He missed his seven dragon friends.

And he wanted more food.

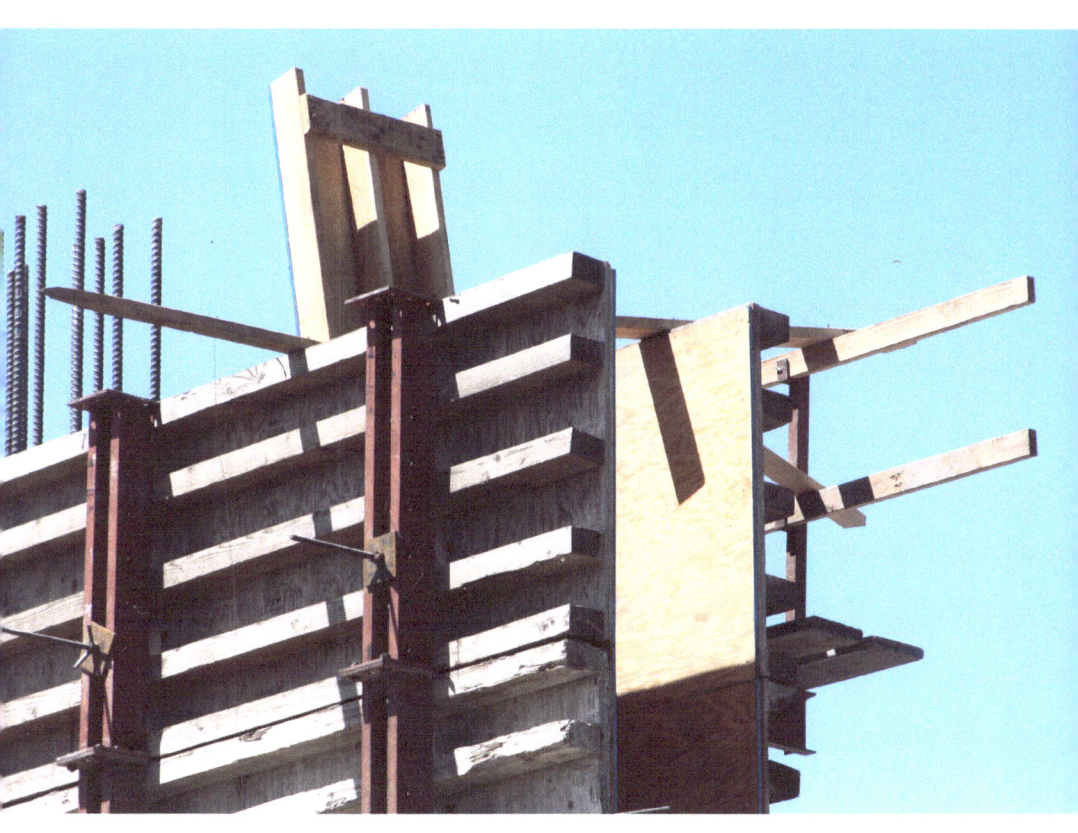

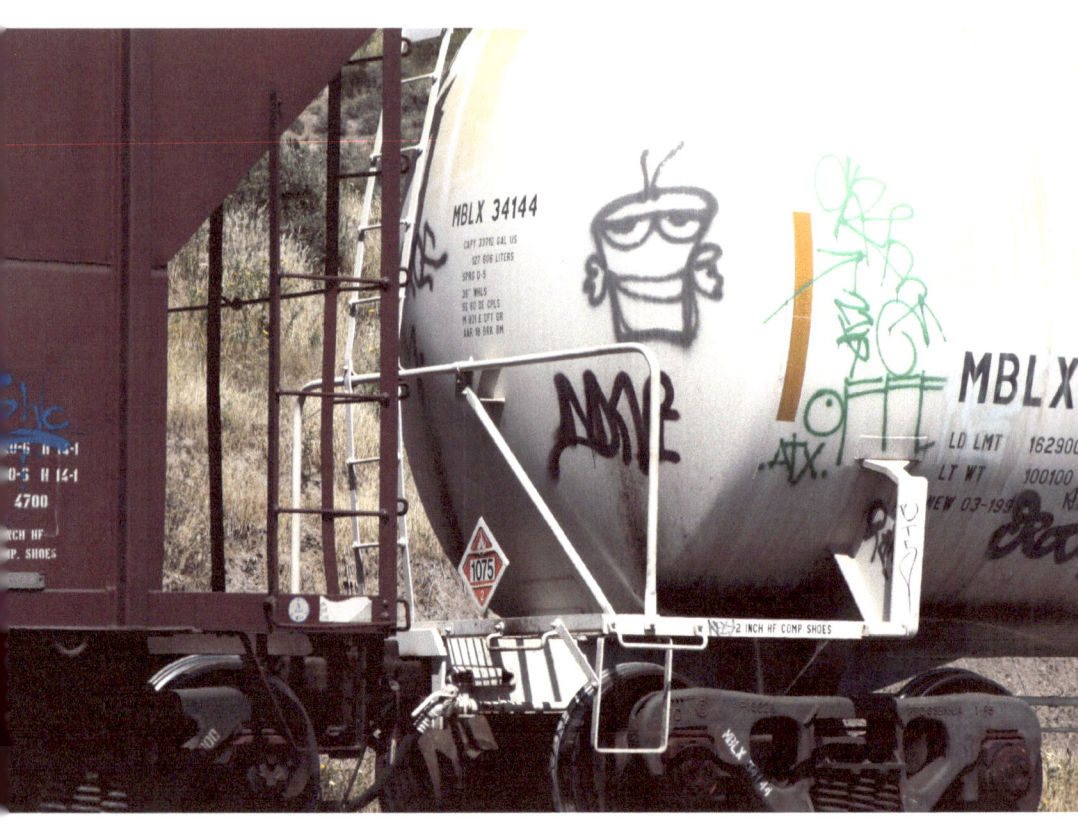

We took my dragon back to Miss Apataska
before we had to feed him
supper that night.

My dragon was so big
he had to balance
with only one foot
on the roof of the car.

My dragon was crying
when we said goodbye.

Then he ran to play
with his seven dragon friends.

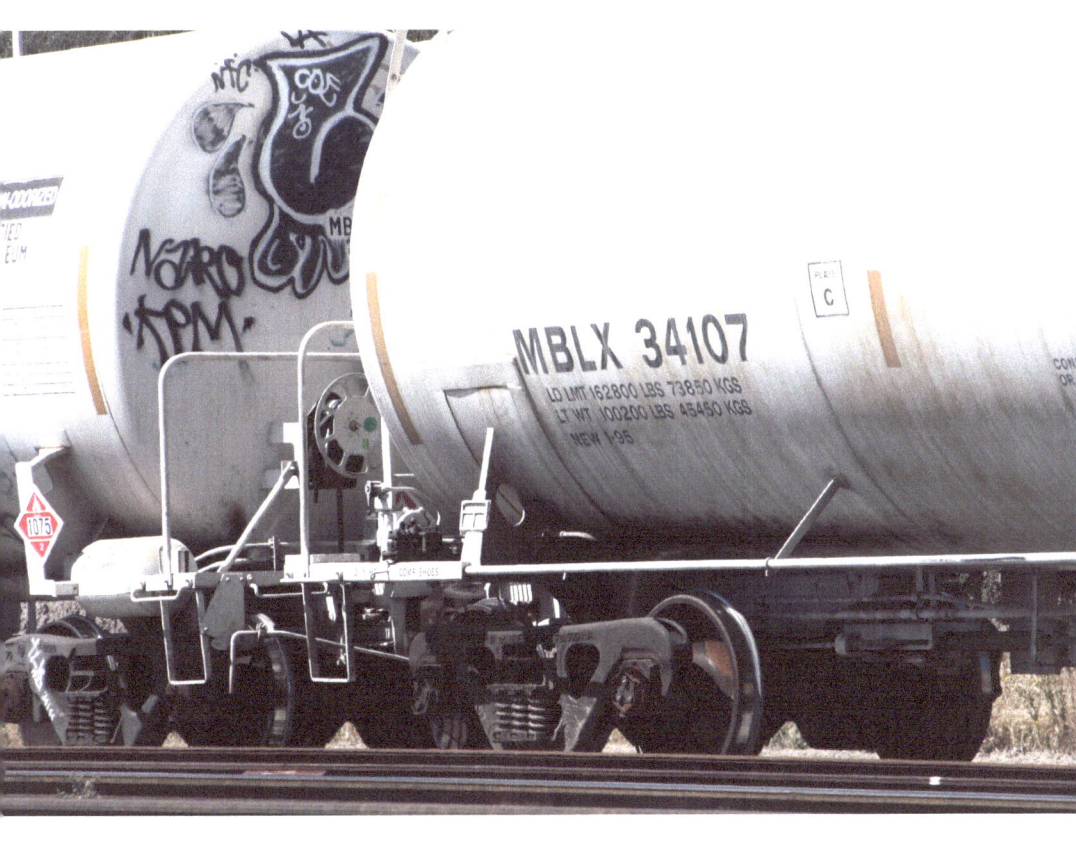

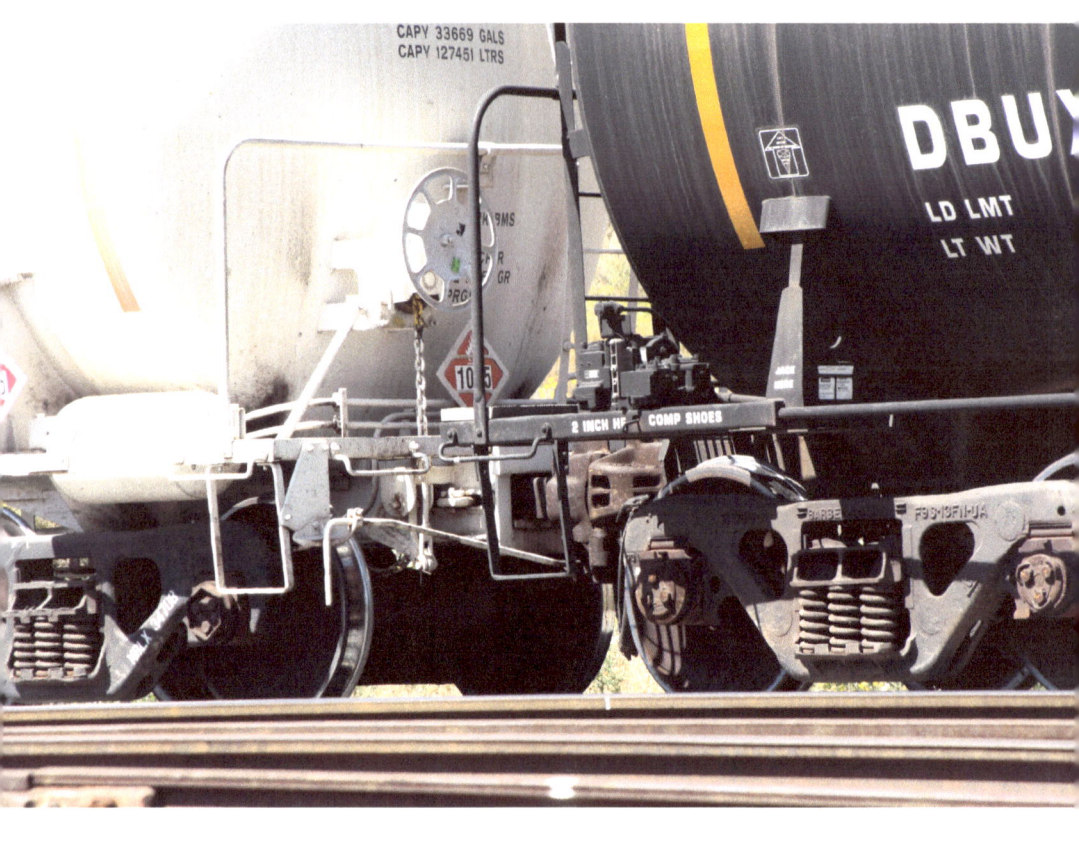

Miss Apataska said she'd give me
any two animals I wanted
in trade for my dragon.

I looked at all the pets in the store:
snails, hamsters, goldfish. . .

I even looked at everything
in the Exotic Animal room.

But nothing looked as good
as the lop-eared bunny
and the English sheep dog
I wanted.

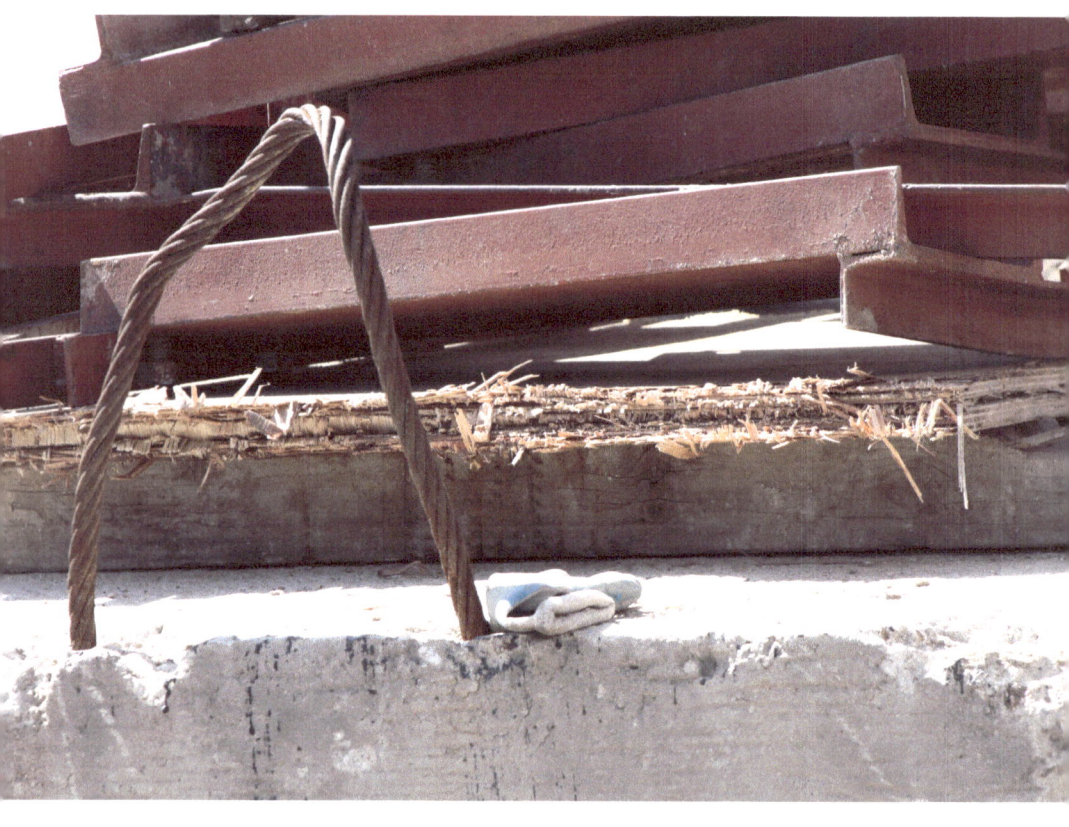

As we were leaving,
Miss Apataska gave me a present
from the Exotic Animal room.

It was a large egg with silver stripes.

I'm keeping the egg warm and very safe.
Because you never know –
it could be anything!

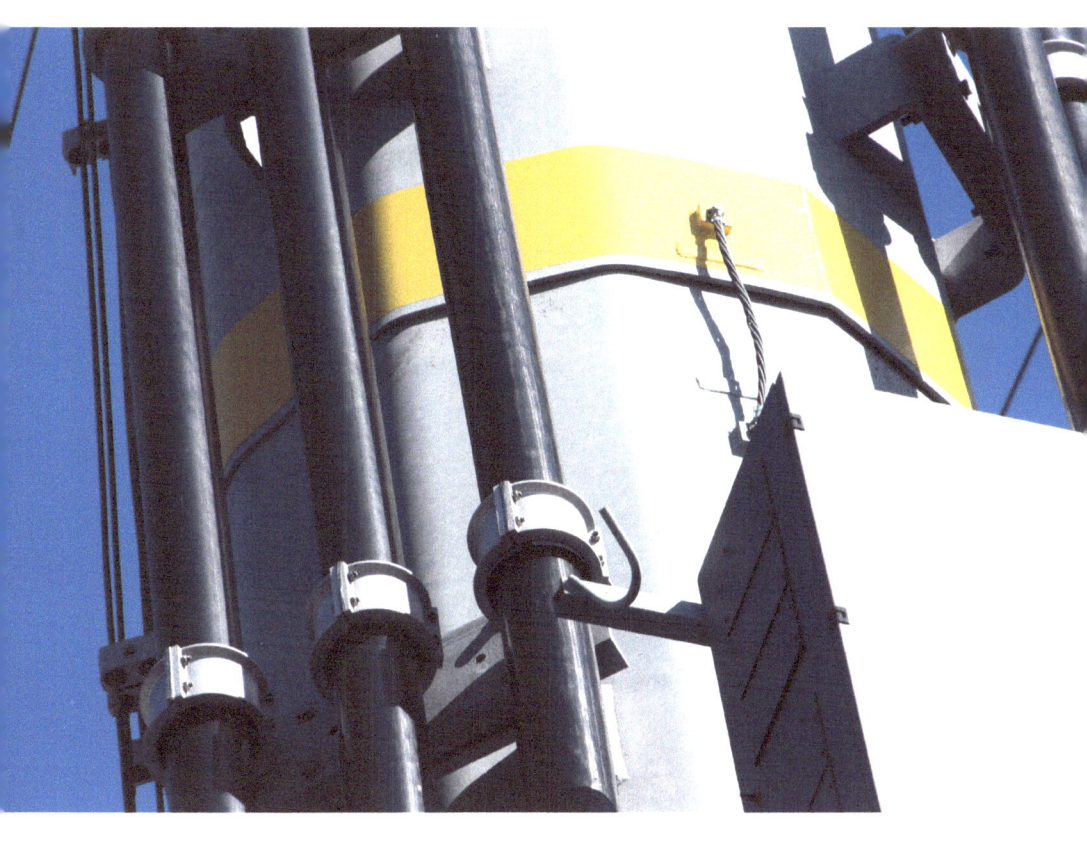

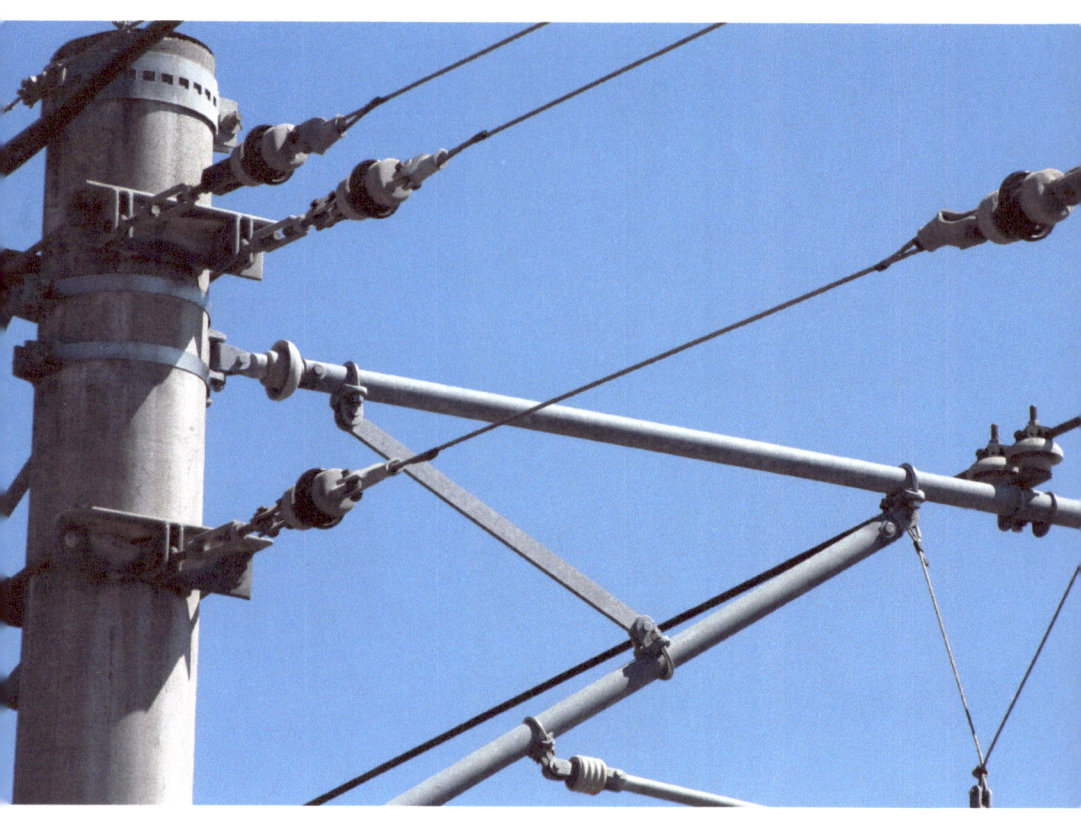

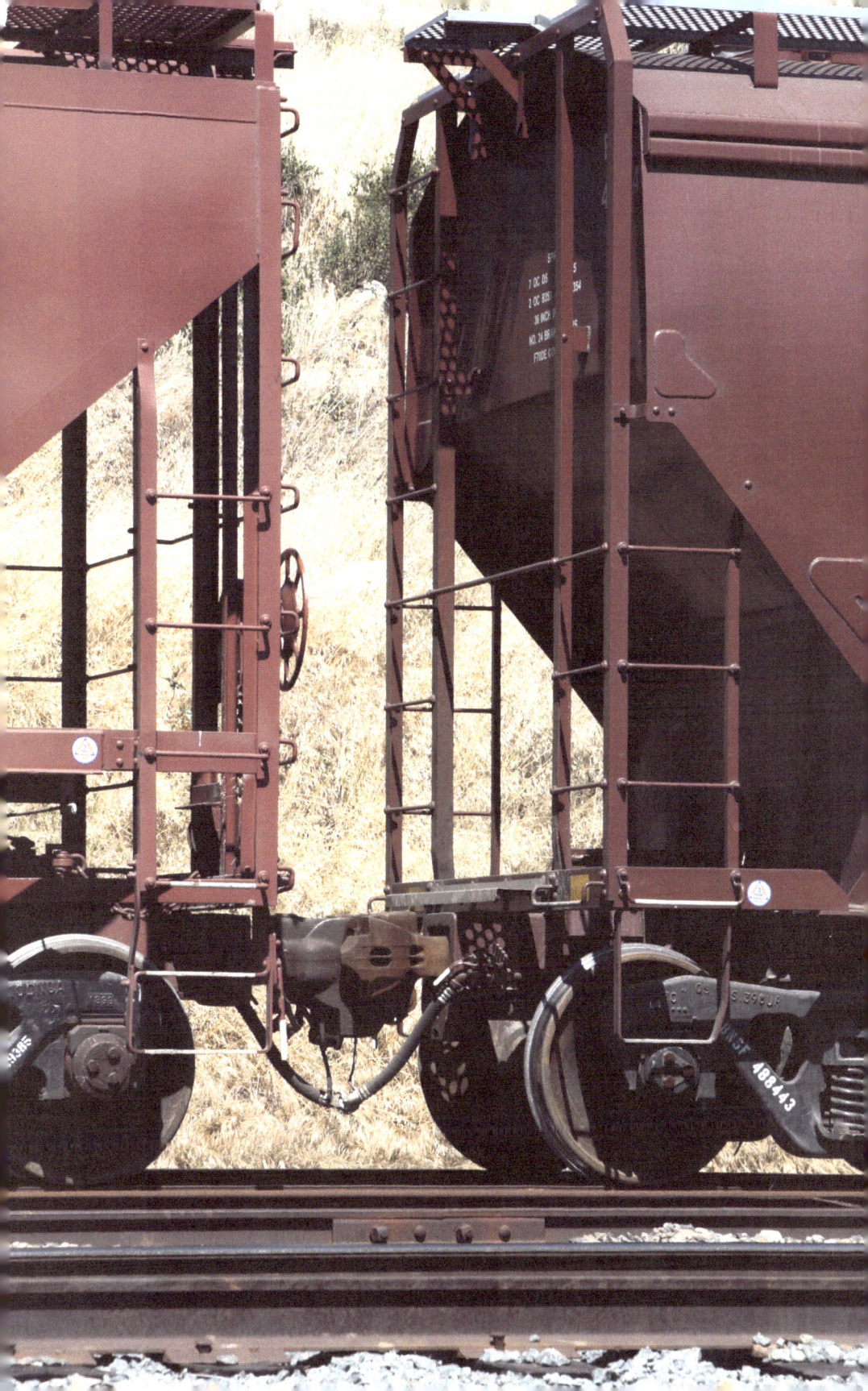

This Mark Dahle Portfolio includes a colorful painting, twenty-six beautiful photographs of Venice, Italy, and a story about a time traveler on his twenty-first trip to the future. From the story:

> Hyptrolysis *always* works. He'll think it was his own idea. If he doesn't make it back, he'll think it was his own fault.

A Mark Dahle Portfolio

Trip 21

This Mark Dahle Portfolio includes a gorgeous abstract painting, twenty-five beautiful photographs of construction in Basel, Switzerland, and a story about a group of trolls moving to Norway.

> When the trolls moved, they had to pass through a large forest. The trees and the trolls kept bumping into each other. It was no fault of the trees.

A Mark Dahle Portfolio

When The Trolls Moved

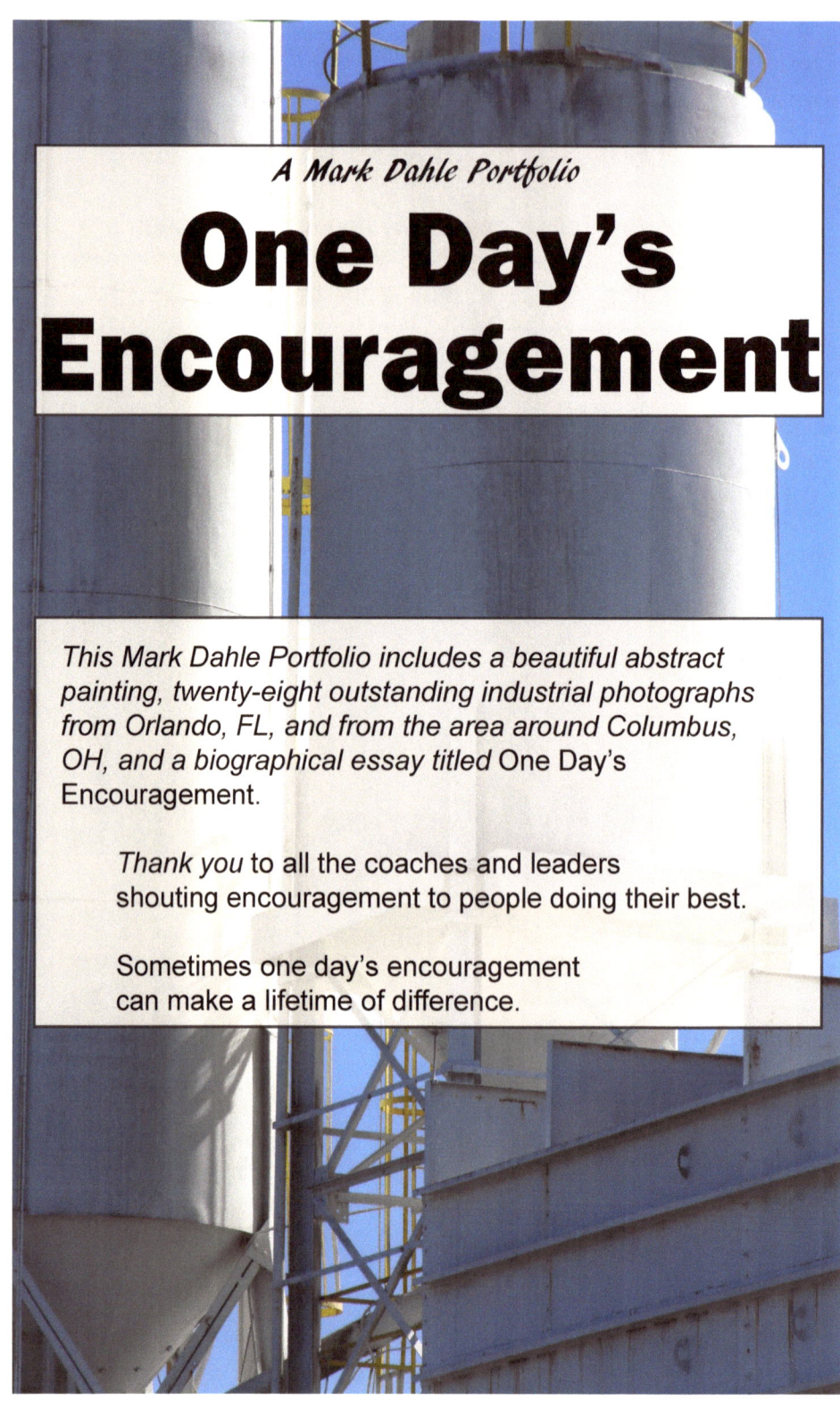

A Mark Dahle Portfolio

One Day's Encouragement

This Mark Dahle Portfolio includes a beautiful abstract painting, twenty-eight outstanding industrial photographs from Orlando, FL, and from the area around Columbus, OH, and a biographical essay titled One Day's Encouragement.

Thank you to all the coaches and leaders shouting encouragement to people doing their best.

Sometimes one day's encouragement can make a lifetime of difference.

www.ingramcontent.com/pod-product-compliance
Lightning Source LLC
Chambersburg PA
CBHW041110180526
45172CB00001B/185